Maharajas

at the London Studios

Maharajas at the London Studios

National Portrait Gallery, London

Russell Harris

Lustre Press
Roli Books

The technique of photography is first recorded as having reached India in 1840, where, as in other parts of the Empire, the British saw the craft as a means of documenting their possessions and the colourful inhabitants of their far-flung territories. Just as Napoleon's invasion of Egypt had brought with it a team of scientists to sketch, document, and decipher the monuments of Egypt (resulting in the publishing of the spectacular *Description de l'Égypte*), the British also began photographing the more romantic vistas of their Indian territories, and documented the 'native types' who populated them.

In England, the fashion of having portraits made over the course of many sittings by the great painters of the day, progressed with the times. The invention of photography was a democratising process, and both the grand and the humble flocked to the new photographic studios to have their images made and to record memorable events in their lives. Some of these

great studios, such as Lafayette Ltd. of London and Dublin, advertised themselves as 'photographic artists'.

Maharaja Sir Bhawani Singh of Jhalawar

Today the National Portrait Gallery, London, has in its possession, prints made by some of the finest colonial photographers. Alexander Bassano, Bourne and Shepherd, Sir Benjamin Stone, Walter Stoneman, Underwood and Underwood, and Herbert Vandyk are six of these photographic institutions featured here.

One of the earliest commercial studios was started by Alexander Bassano (1829-1913) in 1850 in Regent Street, London. In 1876 the studio moved to 25, Old Bond Street which, during the last quarter of the nineteenth century, was a favoured location for studios due to its proximity to most of the venues of official London. The studio was large enough

to accommodate an eighty-foot panoramic background scene mounted on rollers, which provided for a variety of outdoor scenes or court settings.

The later vogue for photo-realistic images would have been considered vulgar, and clients wanted their images to be a work of art, whether this meant commissioning the photographer to retouch complexions, alter waistlines, tidy up stray hair, tint, hand colour, or paint in more magnificent backgrounds than were available in the photographic studios. An added advantage of the photograph, in its many sizes from the popular and cheap *carte visite* to the standard studio-size cabinet *carte*, was that, unlike a painted portrait, many copies could be ordered. The Maharaja of Patiala ordered up to five dozen prints at one time. In public terms, at least in England, the photographic postcards of the great beauties of the day, such as the Countess of Warwick, Lillie Langtry, and Queen Alexandra, were produced in thousands. No longer were the

rulers of empires, countries, or states distant figures; in fact, the distribution of their photographic images meant that their features became familiar to the masses.

The Maharaja of Patiala's public images personified the usual complaints linked with the princes who were accused of squandering the revenues of their states on 'their personal pleasures and salaries of a large number of officers, staff, and great pomp and glory' In 1911 Herbert Vandyk photographed Sir Bhupendra Singh of Patiala swathed in silks, pearls, diamonds, rubies, and emeralds. No matter how much jewellery he added to his costume, and however many orders and

H.H. Sir Pratab Singh, Maharaja of Idar and Regent of Jodhpur (standing) and Sumair Singhji, scion of the Jodhpur family

decorations he pinned on his chest, he was outdone by his son and heir, Sir Yadavindra Singh, who ingeniously succeeded in making a diamond tiara an integral part of his turban ornamentation. In fact, the bejewelled rulers of 'India' represented a threat to established British expectations of male and female attire, to the point where English ladies setting off for India were advised 'to wear much jewellery so as not to be outshone by the Indian princes'.

Herbert Vandyk studied photography in Berlin and Paris and, having served his apprenticeship under his father Charles Vandyk, took over as head of Vandyk Ltd., on his father's retirement in 1902. The premises in London on Buckingham Palace Road were rebuilt in 1913 and equipped with 'an almost prodigal, lighting installation' consisting of six mercury vapour lamps and four half-watt lamps, which enabled him 'to work as freely at night as in the best daylight'. Vandyk was careful to make sure that his images contained 'no harsh shadows, but

luminous tones everywhere'. The whole set-up of two studios, a lounge, four dressing rooms, offices and several darkrooms, was so elaborate 'that the thousands of clients – many of them of royal blood – who visited them, could only leave with a feeling of admiration for the premises and inspired with confidence that their portraits would be the best possible. Few photographers, if any, could claim the patronage of so many members of royalty, Indian princes and, statesmen ' Patronage indeed! For in 1926 Vandyk was invited by the Maharaja of Patiala to go to India 'for the purpose of supervising the erection of a State Palace portrait studio built on the same plans as his own studio in London.

The name of Samuel Bourne (1834-1912) is synonymous with British Indian photography. He is the most researched and highly praised colonial photographer. The Bourne and Shepherd studio continues to operate in Calcutta. Bourne's photographs have what his contemporaries described as a 'luminescent

quality' that exemplifies classic Raj photography. Photographer Satish Sharma stated: 'For the Maharajas, having a portrait done by Bourne and Shepherd during the annual Calcutta season was necessary to define their social status and to make it visible to themselves and to others'.

The images range from the highly formal ones of Sir Fateh Singh of Udaipur and Sir Saurindra Mohan of Tagore, obviously made by Bourne and Shepherd for commercial release, to the Vandyk 'backstairs' images of the Patiala royal family, which were marked 'not for publication'. These images captured, in a hurriedly-constructed and imperfect set, the shy giggles of some the Maharaja's female retinue. It is intriguing to think that these reticent girls were some of the '50 to 60 women in transparent swimming costumes floating on ice blocks and serving drinks and snacks . . .', a scene much reported by visitors to the Maharaja's palace.

London of the 1920s and 1930s appeared to offer visiting Indian princes the opportunity to be photographed in a much more intimate fashion than had previously been seen in the great illustrated documentary publications of the turn of the century, such as the *Who's Who in India* and the *Historical Record of the Delhi Durbar.* Apart from Vandyk, Bourne, and Bassano, other popular photographers among Indian royalty were Sir Benjamin Stone, Walter Stoneman, and Underwood and Underwood.

Sir Benjamin Stone (1838-1914) was the Member of Parliament for East Birmingham, President of the National Photographic Record Association, and appointed by King George V as official photographer of his 1911 Coronation. Many of his

H.H. Yuvraja Sri Sir Kanthirava Narasimharaja Wodeyar Bahadur of Mysore

subjects were foreign dignitaries visiting the Palace of Westminster. For an amateur, he had a prodigious output of over 30,000 negatives. Some of his documentary work has served as valuable historical record, and his images provided useful detail in the reconstruction of Windsor Castle after the fire in 1992.

Walter Stoneman (1876-1958) was a Fellow of the Royal Photographic Society. He worked for sixty years as a portrait photographer and counted portraits of more that 6,000 'men of note' among his output. The National Portrait Gallery owns 10,000 of his photographic portraits, including King George V and Sir Winston Spencer Churchill.

Underwood and Underwood comprised the brother team of Bert Elias Underwood (1862-1943) and Elmer Underwood (1860-1947). By the late nineteenth century, the viewing of stereoscopic slides through a special viewer was a widespread form of entertainment. The two brothers from Illinois had been producing single

stereoscopic slides of scenes from various wars since the 1880s, although portraits credited to the firm were probably made by Elmer. Their innovative 'Tour of the World' boxed slide sets proved so successful, that by 1901 the company was producing 25,000 stereographs a day. Stereoscopic cards were still used as educational tools in public schools and colleges throughout the United States until the early 1950s.

Vandyk managed to photograph Ranji, the cricketing Maharaja of Nawanagar, in a casual suit and cardigan, looking the elegant gentleman that he was reputed to be. In 1933 the Viceroy (Lord Wellington) was accused of having 'so snubbed the Maharaja Ranjit Singh as to cause him to die of heart shock'. Sir Hari Singh of Jammu and Kashmir appears as a Hollywood film star with an immaculate, starched collar and tiepin, and the hard-spending Princess Sudhira of Cooch Behar seems happy to be photographed wrapped in very un-Indian sable!

In 1904 Sir Henry Cotton had written that the Indian rulers 'vie with one another in their enthusiastic reception of the Viceroy on his occasional visits, and in the display of those barbaric attributes of loyalty'. These Indian princes were, as Lord Hardinge (Viceroy from 1910-1916) called them 'Helpers and Colleagues in the great task of Imperial Rule' – even if V.P. Menon referred to the conditions under which the princes and maharajas operated as 'the pathetic plight of the rulers'. However, almost until the last moment, they were for the British the cornerstone of the Empire's vast possessions in India. They were only rebuked when their excesses became a matter of public knowledge – or, one might add, when they messed about with European women. The local rulers were given almost free rein by the Paramount Power to counterbalance the currents of incipient democracy and nationalism. Also it was thought that their preservation would help dampen 'the

■ H.H.Yuvraja Sri Sir Kanthirava Narasimharaja Wodeyar Bahadur of Mysore (1888-1940)

The pin in the Yuvraja's headdress shows the state emblem – Ghanbherunda – the double-headed eagle of Mysore.
Image: Bassano, 24 June 1920

- H.H. Fazand-i-khas-i-Daulat-i-Inglishia Mansur-i-Zaman, Amir-ul-Umara, Maharaj-Adhiraj Rajeshwar Sri Maharaja-i-Rajagan Sir Bhupendra Singh Mahindar Bahadur, Maharaja of Patiala (1891-1938) and members of his family

Sir Bhupendra Singh was the grandfather of the present scion Captain Amarinder Singh, who is actively involved in politics and is Chairman, Indian National Trust for Art and Cultural Heritage.

Image: Vandyk, 24 January 1931

■ H.H. Maharaj Rana Sir Bhawani Singh Bahadur of Jhalawar (1874-1929)

The Maharaja personally supervised relief work during the famine that struck Jhalawar in Rajasthan in 1900. The Rajput Herald claimed 'we can proudly say that he is an ideal Rajput.' During the First World War, he organised weekly lectures for his people 'designed to spread correct information and to be an antidote to the inveterate Indian tendency to alarming rumour'. This image is possibly connected with the admission to Christ Church, Oxford, of his heir, Kumar Rajendra Singh.

Image: Bassano, 25 September 1920

■ H.H. Farzand-i-Khas-i-Daulat-i-Inglishia, Shrimant Maharaja Sir Sayajirao III Gaekwad, Sena Khas Khel Shamsher Bahadur, Maharaja of Baroda (1863-1939)

H.H. Shrimant Akhand Soubhagyavati Maharani Chimna Bai II alias Gajra Bai Sahib, Maharani of Baroda (1872-1940s)

The Maharaja believed in educating women and wrote 'An educated lady in the house is more able to shed the light of happiness than one who is ignorant.' Five years after her trip abroad, the Maharani wrote of her experiences of America. 'They are vulgar. Else why should they stare at me on the streets as they do at the tigers in a circus parade, merely because I wear different and more reasonable garments than their own.'

Image: Benjamin Stone, 5 July 1905

■ Sri Maharaj Kumari Sudhira Sundari Devi of Cooch Behar, later Mrs Allen Mander (1894-1968)

'The Princess is wearing a sable muff and stole, over a full-length fur coat. It may have been Sudhira's taste for [sable] which led The Tatler to report in 1915 that the Maharaja of Cooch Behar's youngest daughter "was last week at the Law Courts sued by a well-known firm of Court dressmakers."' The Princess was the paternal aunt of Maharani Gayatri Devi of Jaipur.

Image: Bassano, 24 December 1910

■ H.H. Farzand-i-Khas-i-Daulat-i-Inglishia, Shrimant Maharaja Sir Sayajirao III Gaekwad, Sena Khas Khel Shamsher Bahadur, Maharaja of Baroda (1863-1939)

This image was taken around the time that the Maharaja was offering his daughter Indira, future mother of Maharani Gayatri Devi of Jaipur, to the Maharaja Scindia of Gwalior, as a bride. Although the Maharaja lead a morally austere life, in December 1911 he was cited in The Times as 'co-respondent in a suit for the dissolution of the marriage of Statham v. Statham.'

Image: Vandyk, 21 June 1911

■ Nawab Muhammad Iftikhar Ali Khan Bahadur, Hanifi ul-Muzhab, Nawab of Pataudi (1910–1952)

The Nawab was a successful international cricketer, and was named 'Wisden Cricketer of the Year' in 1932. Ten years from the date of this image the Nawab married H.H. Sikander Saulat, Iftikhar ul-Mulk, Nawab Mehr Taj Sajida Sultan Begum Sahiba, Nawab Begum of Bhopal (second daughter of Prince Hamidullah of Bhopal). His son Mansur Ali Khan, popularly known as 'Tiger' Pataudi is an equally well-known cricketer.

Image: Bassano, 15 September 1929

■ Lieutenant-General H.H. Sipar-i-Sultanat, Shriman Indar Mahinder Raj Rajeshwar Maharajadhiraja Shri Sir Hari Singhji Bahadur, Maharaja of Jammu and Kashmir (1895-1961)

The dapper Hari Singh, the last Maharaja of Kashmir, achieved international notoriety following an adultery-blackmail scandal in London during which he was referred to in the press as 'Mr A'. His son Dr Karan Singh is an acclaimed scholar and writer, who was Head of State for eighteen years as Regent, as Sadar-i-Riyasat and as Governor till 1967 when he was appointed the youngest ever Cabinet Minister in the country.
Image: Vandyk, 19 January 1920

■ Lieutenant-General H.H. Ali Jah, Umdat ul-Umara, Hisam us-Sultanat, Mukhtar ul-Mulk, A'zim ul-Iqtidar, Rafi-us-Shan Wala Shukoh, Muhtasham-i-Dauran, Maharajadhiraja Maharaja Sir Madho Rao Scindia Bahadur, Shrinath, Mansur-i-Zaman, Fidvi-i-Hazrat-i-Malik-i-Mua'zzam, Rafi-ud-Darja-i-Inglistan, Maharaja Scindia of Gwalior (1876-1925)

H.F. Prevost Battersby, who had accompanied the Prince of Wales in 1903, wrote that the Maharaja 'does not seek his pleasures in Simla or Paris, he finds them in work among his own people.' This image was taken during his visit to London, for the Coronation of King George V. His grandson Madhav Rao Scindia has been very actively involved in politics for several decades and is a leading member of the Congress Party.

Image: c. 1911

■ H.H. Maharao Shri Mirza Raja Sawai Sir Khengarji Bahadur, Rao of Kutch (1866-1942).

Kutch was described by The Times as 'a vast salt morass which is impassable except in the dry season' and the Maharao as 'one of the most polished and charming of the Indian princes of the older generation.' The Jam Saheb of Nawanagar called him 'the greatest gentleman in India.' This image was made when the Maharao was in London as representative of India to the Imperial Conference of 1921.
Image: Vandyk, 1921

■ General H.H. Walashan Nawab Azam Jah, Sahibzada Mir Himayat Ali Khan Bahadur, Prince of Berar (1907-1970), son of the Nizam of Hyderabad

Image: Vandyk, 14 October 1921

Dear Reader,

We hope you enjoyed reading this book.

As the leading publisher of illustrated and art books, we have a large selection of books that will appeal to your taste. Do take a minute to fill up the card and mail it to us. It will be a pleasure to send you our regular newsletter with information on new releases, special offers and events that we host every month.

What's more, there is a monthly lucky draw for all our readers who send in this card. You may well receive a pleasant surprise from us one of these days.

Sincerely yours,
Kiran Kapoor

My special interests are

○ Contemporary Art ○ Biographies ○ Architecture
○ Travel ○ Cookery ○ Erotica
○ Indian Heritage ○ Politics ○ Business and Management

○ *Please send me a complimentary catalogue*

Name _____

Address _____

City _____ Zip Code _____ Count _____

E-mail _____

Tel:Fax _____

visit: www.rolibooks.com

ROLI BOOKS

M-75, Greater Kailash-II Market,
New Delhi - 48

Tel: 6442271, 6462782, 6460886, Fax: 6467185
E-mail: roli@vsnl.com

■ H.H. Maharaja-Dhiraja Raj Rajeshwar Ravi Kula Bhushna Maharana Sri Sir Fateh Singh Bahadur, Maharana of Udaipur (1848/9-1930)

In his book on the Rajputs, Thakur S.J. Seesodia claimed that Sir Fateh Singh's 'word is law to the 240,000,000 Hindus who inhabit India.' Although the British showered all manner of honours on him, he remained staunchly independent. After the award of one medal, the Maharana told his servant where to place it: 'It looks better on a horse than on a king.' By 1921, the British had become so exasperated by 'Bapuji's' snubs that he was formally deposed.

Image: Bourne and Shepherd

■ Lt. Col. H.H. Zubd-tul-Mulk Dewan Mahkhan Taley Muhammad Khan Bahadur, Nawab of Palanpur (1883-1957)

The Nawab was in England to attend the Coronation. The Nawab's turban brooch has been made to resemble George VI's Royal Family Order.

Image: Walter Stoneman, 1937

■ Lt. Col H.H. Maharaj-Dhiraj Sir Madan Singh Bahadur, Maharaja of Kishangarh (1884-1926)

The Maharaja of Kishangarh married a daughter of Sir Fateh Singh of Udaipur.

Image: Vandyk, 9 January 1915

■ H.H. Fazand-i-Khas-i-Daulat-i-Inglishia Mansur-i-Zaman, Amir-ul-Umara, Maharaj-Adhiraj Rajeshwar Sri Maharaja-i-Rajagan Sir Bhupendra Singh Mahindar Bahadur, Maharaja of Patiala (1891-1938)

The Maharaja 'had a great love for titles and honours. France, Belgium, Spain, and the Vatican, Czechoslovakia, Poland, Egypt, Hungary, and Holland were some of the countries from which he extracted decorations.' The backdrops at the Vandyk studio did not accord with Bhupendra Singh's idea of a background, and in some of his images he commissioned a more statesmanlike background to be painted onto the negative.
Image: Vandyk, 22 April 1931

■ Colonel H.H. Shri Sir Ranjitsinhji (Ranji) Vibhaji, Maharaja Jam Saheb of Nawanagar (1872-1933)

'Ranji' spent many years of his life playing cricket in England. His love of the English way of life is reflected here in his mode of dress which has some of the shabbiness of the English upper classes at rest. The Jam Saheb, although often appearing in portraits in Western dress, also appeared rather fond of being photographed in brocades and positively dripping with emeralds, diamonds and pearls. He is perhaps best remembered as one of the world's best cricketers after whom the Ranji Trophy has been named.
Image: Vandyk, 11 November 1912

■ Major General H.H. Maharaja Raja Ramaraja Sri Padmanabha Dasa Vanchi Pala Bala Rama Varma II, Kulasekhara Kiritapati Manney Sultan Bahadur, Shamsher Jang, Maharaja of Travancore (1912-1991)

The famous painter Raja Ravi Varma comes from this family.
Image: Bassano, 23 June 1933

■ H.H. Farzand-i-Khas-i-Daulat-i-Inglishia, Shrimant Maharaja Sir Sayajirao III Gaekwad, Sena Khas Khel Shamsher Bahadur, Maharaja of Baroda (1863-1939), seated

Major General H.H. Farzand-i-Khas-i-Inglishia, Shrimant Maharaja Sir Pratapsinhrao Gaekwad, Sena Khas Khel Shamsher Bahadur, future Maharaja of Baroda (1908-1968)

Image: Bassano, 24 July 1934

■ General H.H. Walashan Nawab Azam Jah, Sahibzada Mir Himayat Ali Khan Bahadur, Prince of Berar (1907-1970), son of the Nizam of Hyderabad

H.H. Princess Khadija Hayriya Aisha Duri-i-Shahvar Sultana (H.H. Durdana Begum Sahiba, Princess of Berar) (b 1914)

The couple were married at Hilafet Palace, Nice, France on 20 December 1931. The Princess was the daughter of Caliph Abdulmecid Khan II of Turkey. The Princess was a painter and poet and brought modern ideas of the role of women in society to Hyderabad. Some ten years later, the Princess was photographed by Cecil Beaton, who was enamoured of her presence: 'The aquiline nose, the pointed, pouting lips, the large, lean cheekbones and fierce bird-like eyes, were enormously impressive in the manner of primitive sculpture. The wild appearance, though startling, even terrifying, was nevertheless on a grand scale . . .'

Image: Vandyk, 14 October 1932

■ Major General H.H. Sir Pratab Singh (1845-1922) sometime Maharaja of Idar and three times Regent of Jodhpur, (standing)

Colonel H.H. Raj Rajeshwar Saramad-i-Rajha-i-Hindustan Maharajadhiraja Maharaja Shri Sumair Singhji Sahib Bahadur, scion of the Jodhpur family (1898-1918)

Among the princes who volunteered for the front in the First World War was Sir Pratab Singh, who was seventy years old. He took with him his nephew, a youth of sixteen. During the siege of Haifa, Sir Pratab issued his famous order 'You can go forward and be killed by the enemy's bullets or you can fall back and be executed by me!' He epitomised empire derring-do to the point that Lord Hardinge referred to him as 'truly a white man among Indians.' He is perhaps better known as the designer of the long breeches for riding that bear his name.

Image: Vandyk, 24 January 1910

■ Colonel H.H. Alijah Farzind-i-Dilpazir-Daulat-Inglishia, Mukhlis-ud-Daula, Nasir-ul-Mulk, Amir-ul-Umara, Nawab Sir Mohammad Hamid Ali Khan Bahadur, Mustaid Jang, of Rampur (1875-1930)

The Nawab succeeded to the throne at the age of four. He was recognised as a scholar, as well as raconteur, bon-vivant and administrator of great skill. The Nawab was also the owner of one of the finest pearl collections in the world and some portraits show him wearing at least thirty swags at a time.
Image: Vandyk, 2 April 1927

■ H.H. Fazand-i-Khas-i-Daulat-i-Inglishia Mansur-i-Zaman, Amir-ul-Umara, Maharaj-Adhiraj Rajeshwar Sri Maharaja-i-Rajagan Sir Bhupendra Singh Mahindar Bahadur, Maharaja of Patiala (1891-1938)

The Maharaja is seen wearing a modest amount of the Patiala jewels. Many of these diamonds, pearls and emeralds were reset in the early 1930s by Boucheron and Cartier in Paris. The six-pointed diamond star on the Maharaja's chest appears to contain a portrait of a very young Queen Victoria in court dress. It was not a standard Order, and as the Maharaja amassed awards in later years, this particular piece of jewellery appears to have been relegated to his storerooms.

Image: Vandyk, 5 July 1911

■ One of the Maharanis of Patiala

Image: Vandyk, 7 May 1931

■ H.H. Maharaja Sir Pratab Singh, Malvendra Bahadur of Nabha (1919-1995) and members of his family

Image: Bassano, 31 October 1936
■ *Front cover:* H.H. Sir Bhupendra Singh, Maharaja of Patiala
■ *Page 2:* H.H. Sir Bhupendra Singh, Maharaja of Patiala and members of his family
■ *Page 3: (above)* H.H. Sir Bhawani Singh, Maharaja of Jhalawar; *(below)* Nawab Muhammad Iftikhar Ali Khan Bahadur, Nawab of Pataudi
■ *Back cover:* H.H. Sir Sayajirao III Gaekwad, Maharaja of Baroda